Gerald–Not-Practical

by Helena Clare Pittman

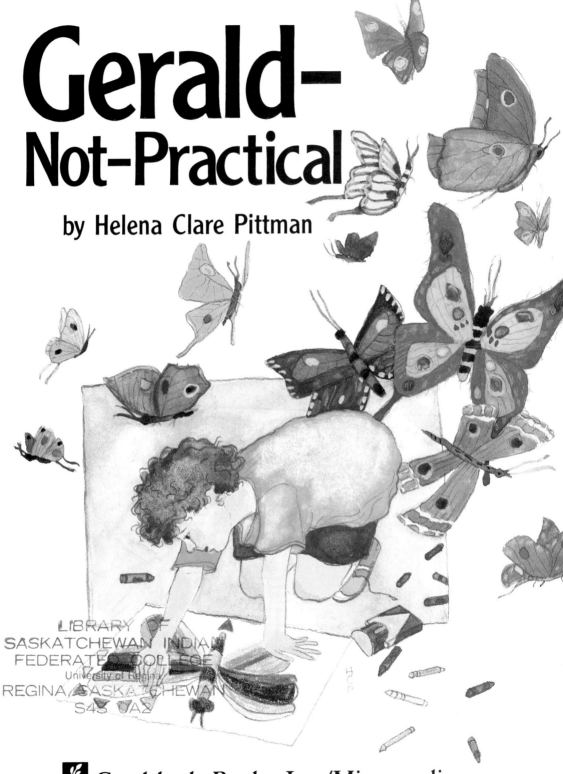

Carolrhoda Books, Inc./Minneapolis

Library of Congress Cataloging-in-Publication Data

Pittman, Helena Clare.
Gerald-not-practical / by Helena Clare Pittman.
p. cm.
Summary: Despite his family's opinion that his love of drawing is
impractical, Gerald insists that his art is important because it
makes him feel good.
ISBN 0-87614-430-X (lib. bdg.)
[1. Drawing—Fiction. 2. Artists—Fiction. 3. Family life—
Fiction. 4. Self-respect—Fiction.] I. Title
PZ7.P689Ge 1990 89-28897
[E]—dc2 CIP
AC

Manufactured in the United States of America

1 2 3 4 5 6 7 8 9 10 99 98 97 96 95 94 93 92 91 90

At last, for Julie with love

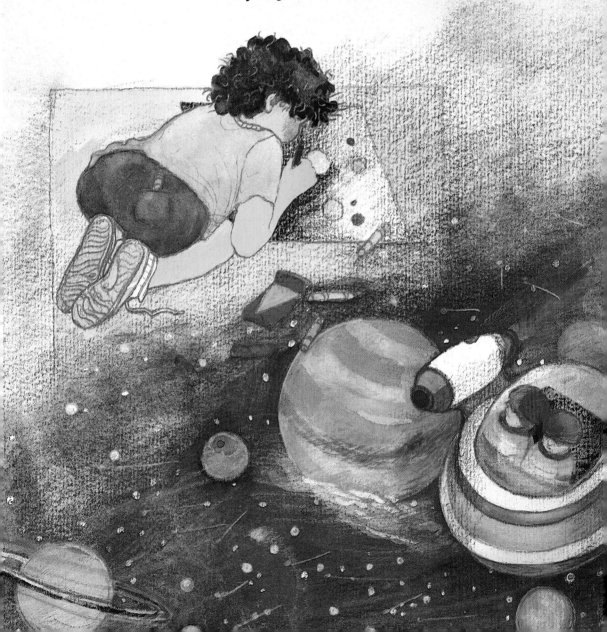

Gerald Jinks liked to draw pictures. He drew herds of horses, beautiful butterflies, moons and stars—anything he could imagine.

He drew all the time and was hardly ever bored, even when he was by himself. Sometimes he even chose to be by himself, drawing or coloring. His family thought that was strange.

"Nice, Gerald," his mother said one day when Gerald showed her his picture. "But not practical."

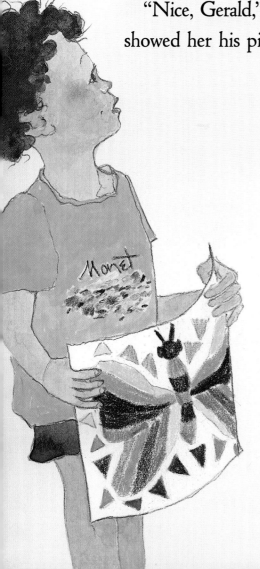

"What's 'practical'?" asked Gerald.

"Practical," said Mrs. Jinks, "is...being able to build something." Then she hammered another nail into the new bookcase she was making to prove her point.

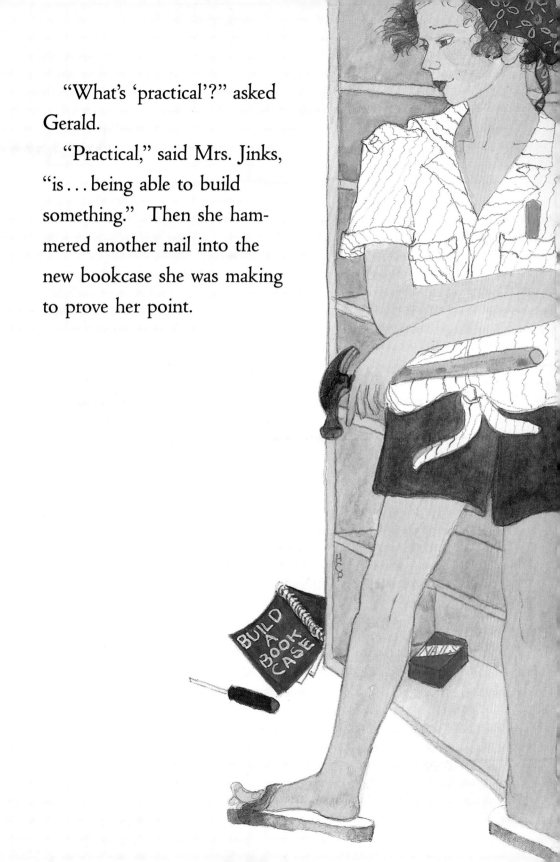

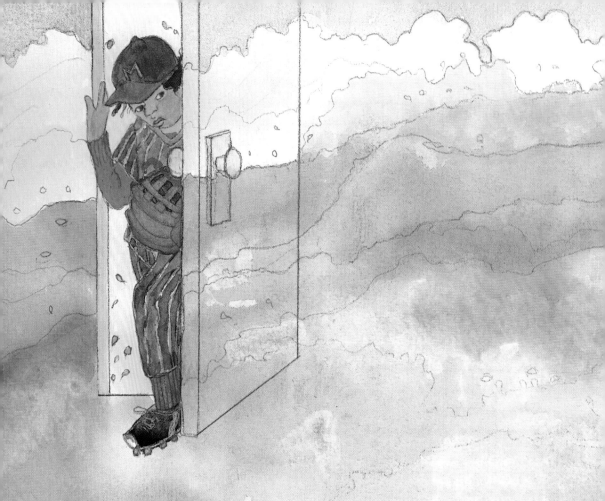

Gerald went back to his picture. He drew a tall
ship tossing on the sea. He colored the sky bright
blue. It was exciting to Gerald that a little thing like a
crayon could change paper into sky.

"Come on, Gerald!" called his brother, Elliot, barging
into the quiet of his sea world. "We need a left fielder."

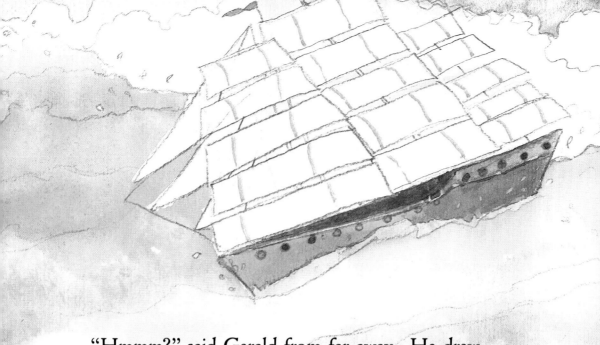

"Hmmm?" said Gerald from far away. He drew some storm clouds with the gray crayon. Then he added some scribbly lines of yellow. Suddenly it looked as if the tall ship were in danger.

Gerald was fascinated. "Just with a few lines!" he exclaimed.

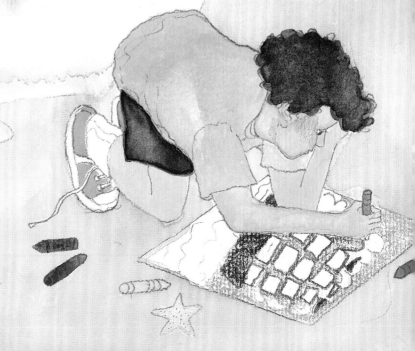

"Look at my picture!" he said to Elliot.

"It's nice," said Elliot. "Come on, Gerald! We need you to play left field."

"I can't. I'm busy," said Gerald, coloring the sails.

"Pictures, pictures!" said his brother. "Why don't you do something practical instead of drawing pictures all day?"

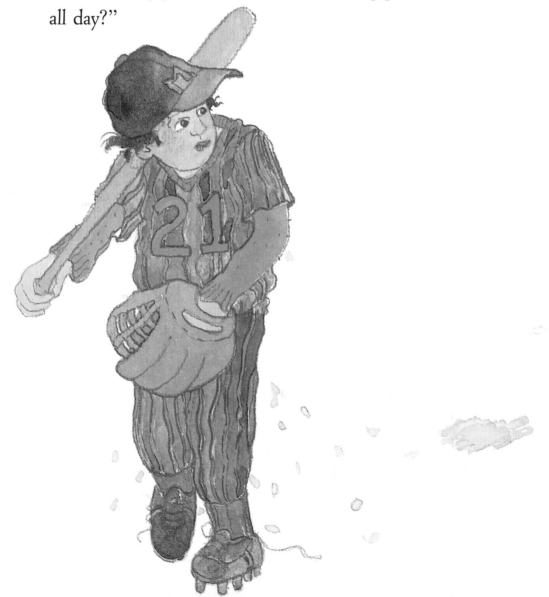

"What's practical?" asked Gerald, frowning.

"Practical," said Elliot, "is...playing baseball!"

Gerald turned back to his picture.

"What a dreamer!" yelled his brother, slamming the door.

Gerald hardly noticed. He had taken up the black crayon to outline the sails. "There," he said. "It's finished."

He held it up. The ship seemed to be tossing on top of the waves.

"Look at that," said Gerald softly. "Just with a few crayons."

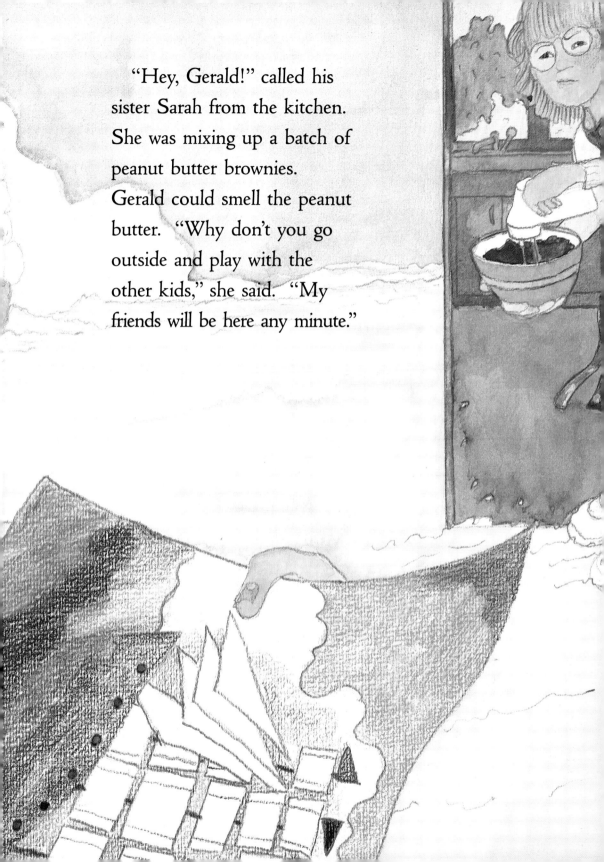

"Hey, Gerald!" called his sister Sarah from the kitchen. She was mixing up a batch of peanut butter brownies. Gerald could smell the peanut butter. "Why don't you go outside and play with the other kids," she said. "My friends will be here any minute."

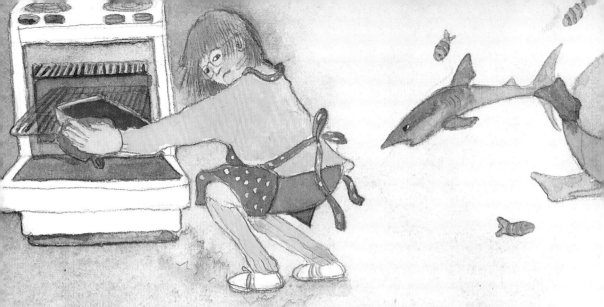

"Look at my picture," said Gerald.

"It's nice," said Sarah. "Now go on outside and play."

"But I want to draw," said Gerald.

"Well, draw outside," said Sarah.

"I can't," said Gerald. "It's too noisy."

"Then go into your room," said his sister.

"Too crowded," said Gerald.

"Use the basement," said Sarah.

"Too dark," said Gerald.

"You'll have to move!" said Sarah. "I'm having company."

"Nuts," said Gerald.

"Drawing's nice, Gerald," said Sarah.
"But it's not . . . practical."

"Practical, practical," said Gerald. "What *is* practical?"

"Practical is making something to eat!" she answered
as she popped the pan of batter into the oven.

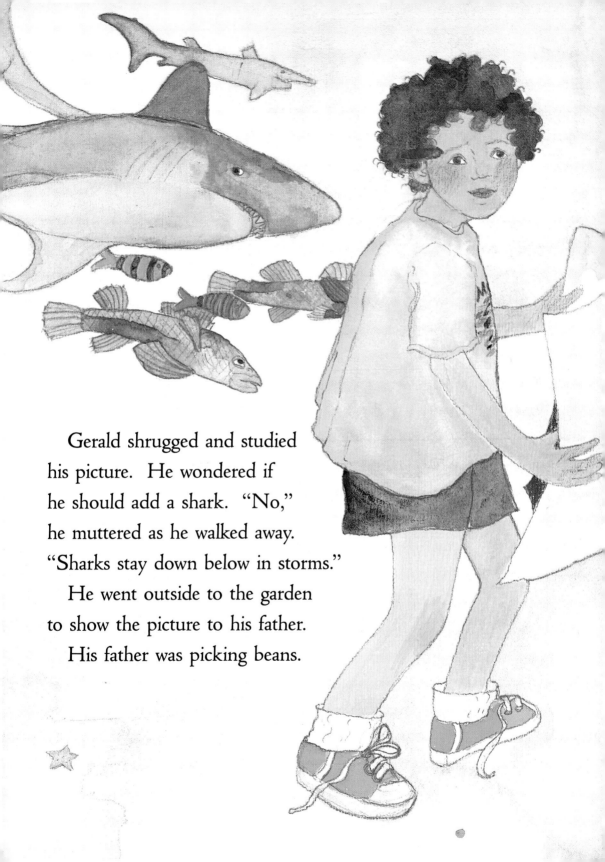

Gerald shrugged and studied
his picture. He wondered if
he should add a shark. "No,"
he muttered as he walked away.
"Sharks stay down below in storms."

He went outside to the garden
to show the picture to his father.
His father was picking beans.

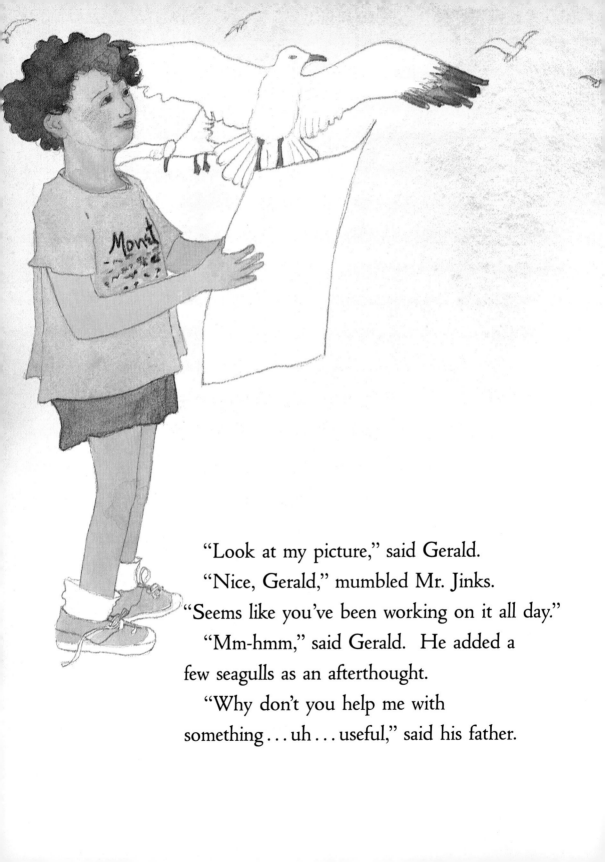

"Look at my picture," said Gerald.

"Nice, Gerald," mumbled Mr. Jinks.
"Seems like you've been working on it all day."

"Mm-hmm," said Gerald. He added a
few seagulls as an afterthought.

"Why don't you help me with
something... uh... useful," said his father.

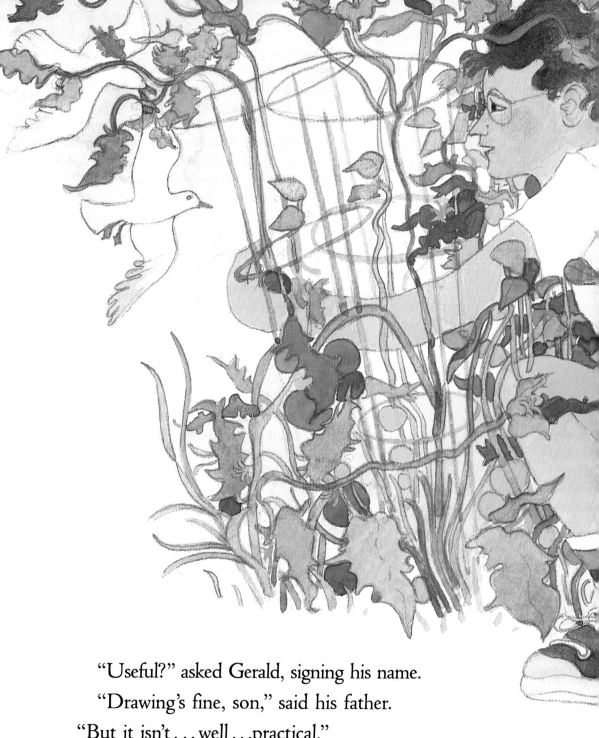

"Useful?" asked Gerald, signing his name.

"Drawing's fine, son," said his father.

"But it isn't . . . well . . . practical."

All of a sudden, Gerald threw down his crayons. "ENOUGH!" he shouted. "PRACTICAL, PRACTICAL, PRACTICAL! THAT'S ALL I EVER HEAR! WHO CARES ABOUT PRACTICAL? DRAWING MAKES ME FEEL GOOD!"

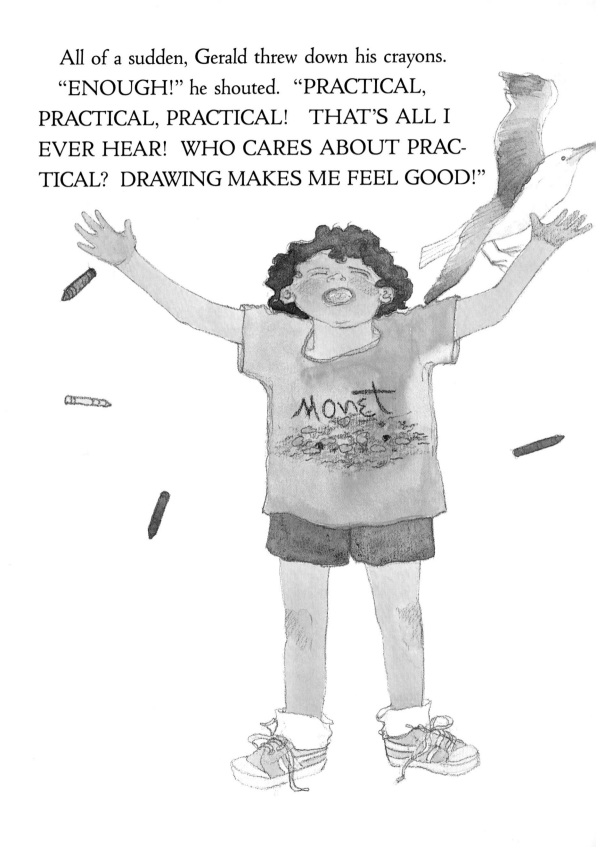

"We had to forfeit!" shouted Gerald's brother, stomping into the backyard. "Thanks to Gerald, we had a gaping hole in left field!"

"What's the matter?" asked Mrs. Jinks, hurrying outside at the sound of raised voices.

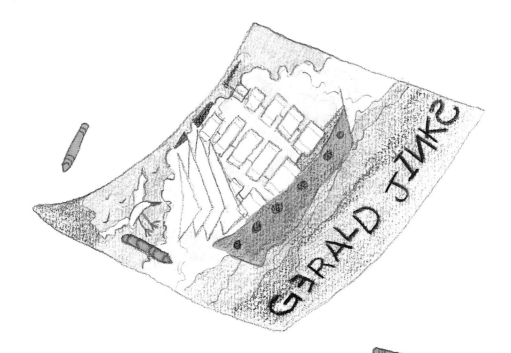

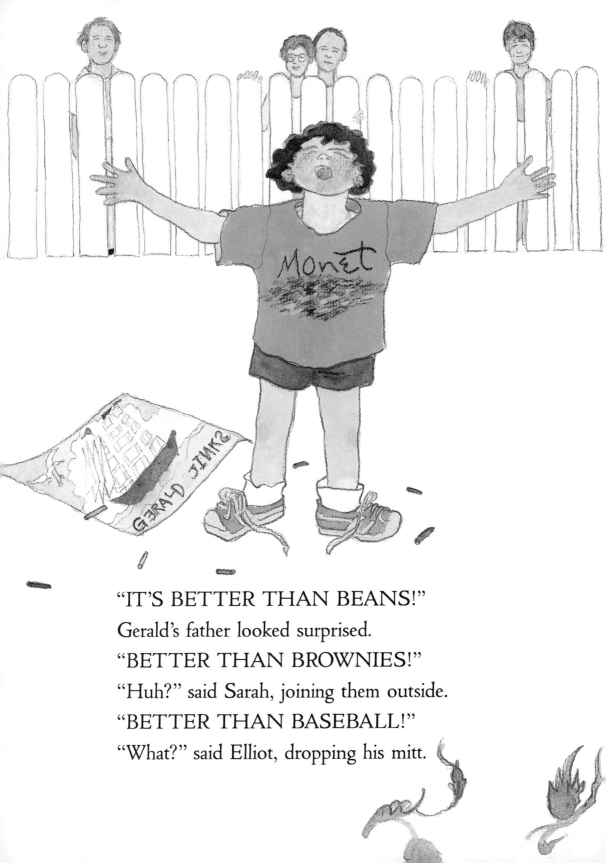

"IT'S BETTER THAN BEANS!"
Gerald's father looked surprised.
"BETTER THAN BROWNIES!"
"Huh?" said Sarah, joining them outside.
"BETTER THAN BASEBALL!"
"What?" said Elliot, dropping his mitt.

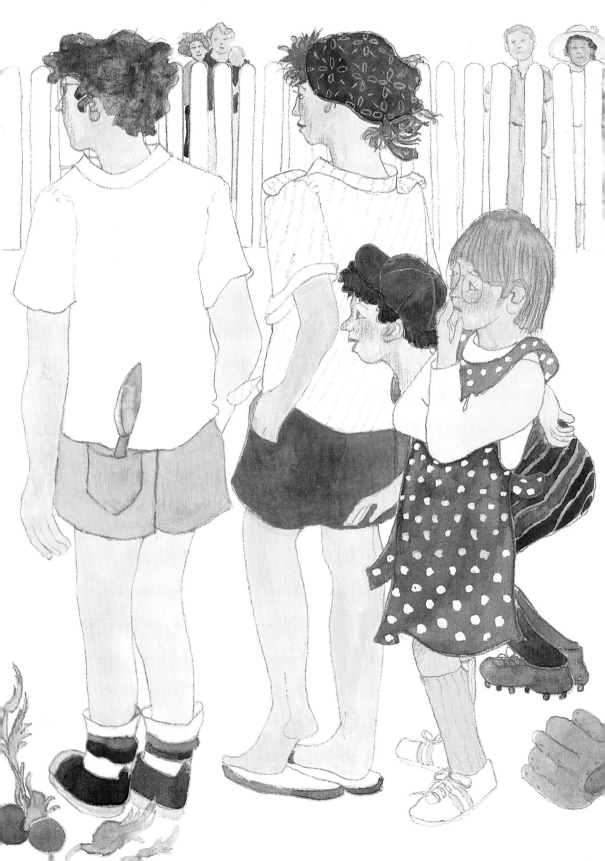

All the neighbors clapped.
Everyone looked at Gerald
and his picture.

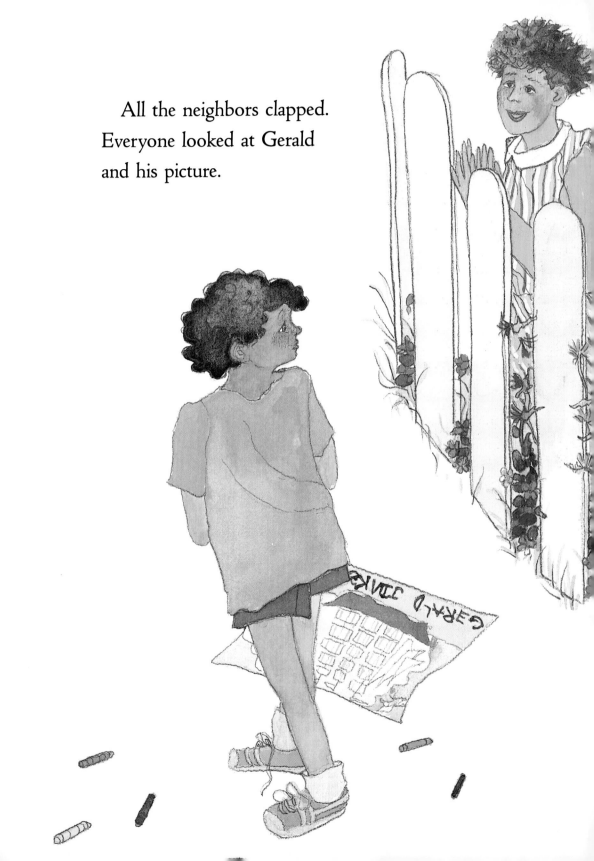

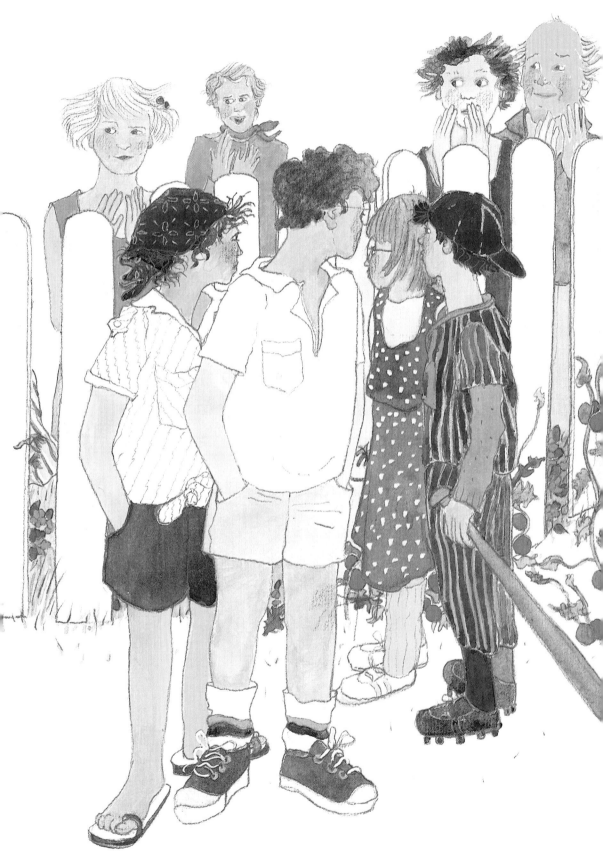

"What a beautiful picture, Gerald," said Gerald's little sister, Jennie, who had just pedalled into the backyard on her tricycle.

"You're really an artist, Gerald," called Mr. Riggs over the fence.

"Nice picture, Gerald," called Mrs. Watson.

"Could you draw one for me to hang over my desk at the office?" asked Mr. Scudder.

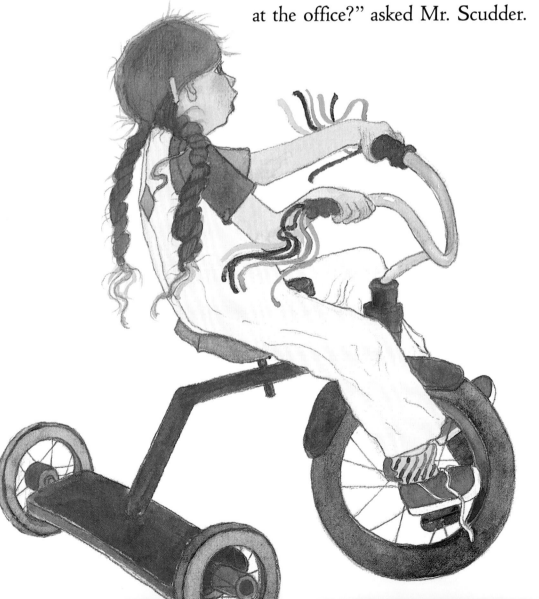

"Sure!" said Gerald.

"How would you like to do one for the community newspaper?" asked Mr. Riggs.

"I'd love to," said Gerald. He went inside to draw a picture of the garden with its tomato plants and climbing beans and the neighbors looking over the fence.

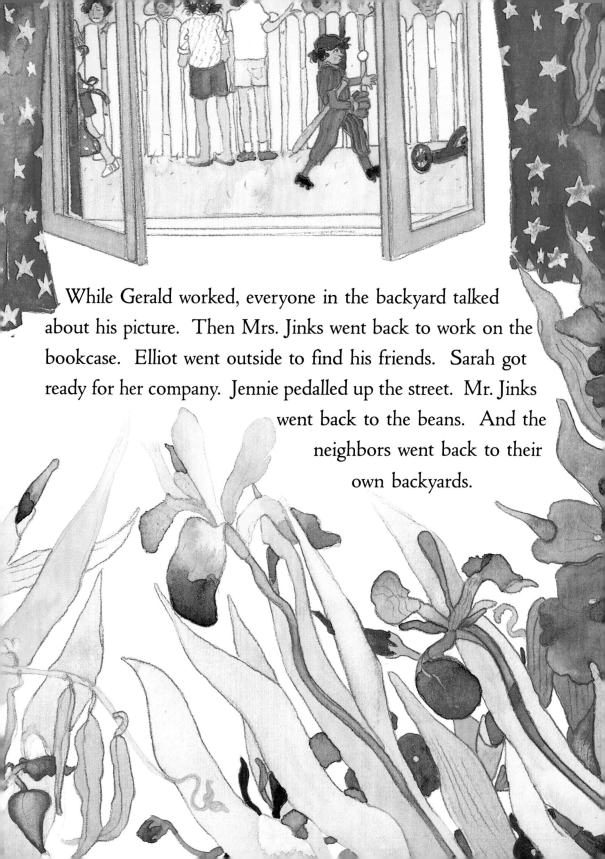

While Gerald worked, everyone in the backyard talked about his picture. Then Mrs. Jinks went back to work on the bookcase. Elliot went outside to find his friends. Sarah got ready for her company. Jennie pedalled up the street. Mr. Jinks went back to the beans. And the neighbors went back to their own backyards.

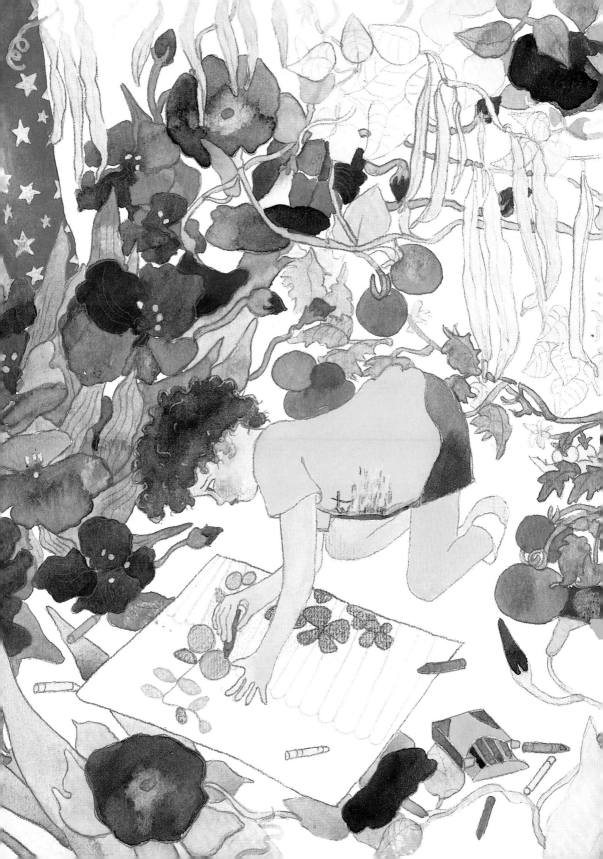

The next day, Gerald's family was waiting in the dining room when Gerald got home from school. There was a package on the table. It was marked *"FOR GERALD."*

Gerald unwrapped the package carefully. Nice paper, thought Gerald. Maybe I could use it in a picture sometime. Inside the wrapping was a new box of sixty-four crayons, a thick pad of blank white paper, and a card.

"Oh boy!" said Gerald. "This is great! This'll make at least a hundred pictures!"

He picked up the card. It read:

"TO GERALD, WHO LOVES TO DRAW. IT'S IMPORTANT TO FEEL GOOD ABOUT WHAT YOU DO. WITH LOVE FROM YOUR FAMILY."

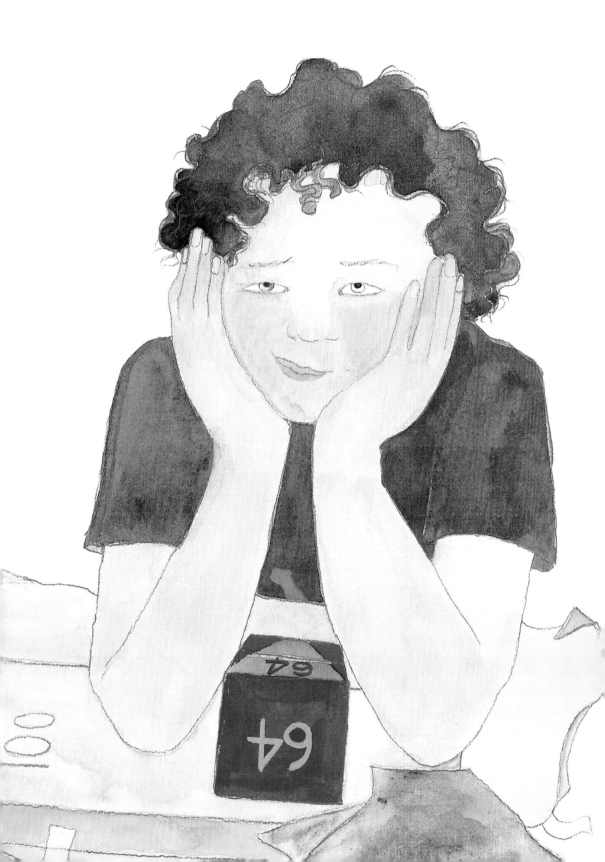

Gerald grinned from ear to ear. "I can't wait to try them! Thanks everybody."

Then he looked thoughtful. "Uh—I'm sorry about yesterday, Elliot. I mean, about the game."

"Yeah," said Elliot, shrugging his shoulders.

"But I'll play left field next week!" said Gerald.

"Great, Gerald!" said Elliot, and he swung his pitching arm into a wind-up.

"You know, Gerald," said Mr. Jinks, "there was a story in the newspaper today about an artist who sold a picture to a museum for ten thousand dollars!"

"*That's* practical!" said Mrs. Jinks.

"*That's* practical!" said Elliot.

"*That's* practical!" said Sarah.

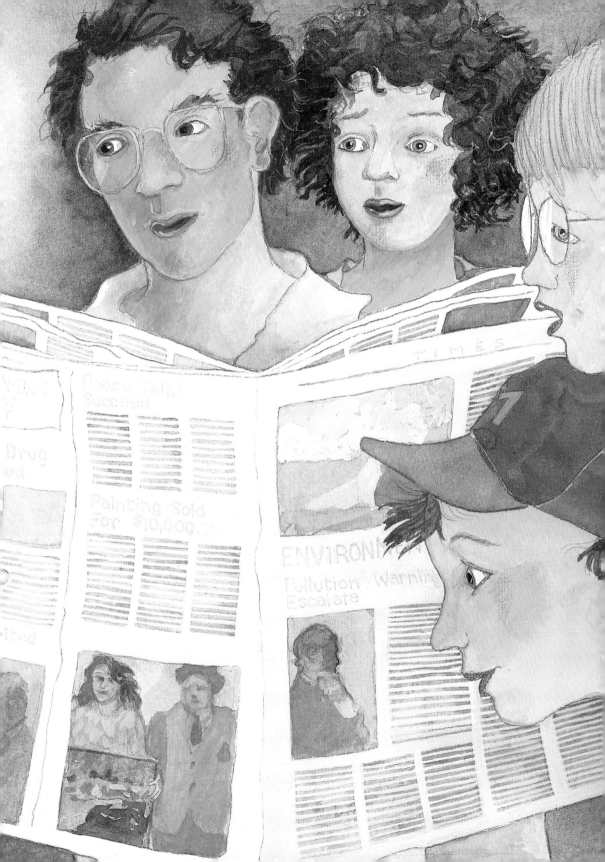

Gerald smiled. He picked
up his new pad and crayons
and began another picture.

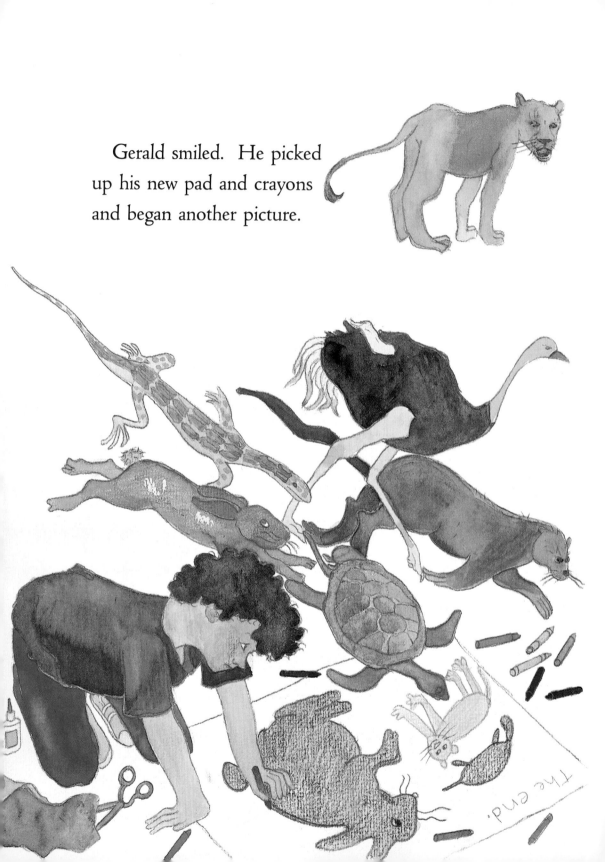